ANNE GEDDES

Little Thoughts *with* Love

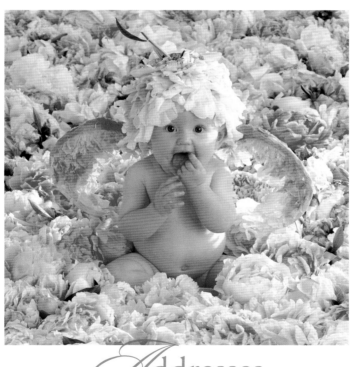

Addresses

Name

Address

Fax/Email

Phone(s)

Name

Address

Fax/Email

Phone(s)

Name

Address

Fax/Email

Phone(s)

Name

Address

Fax/Email

Phone(s)

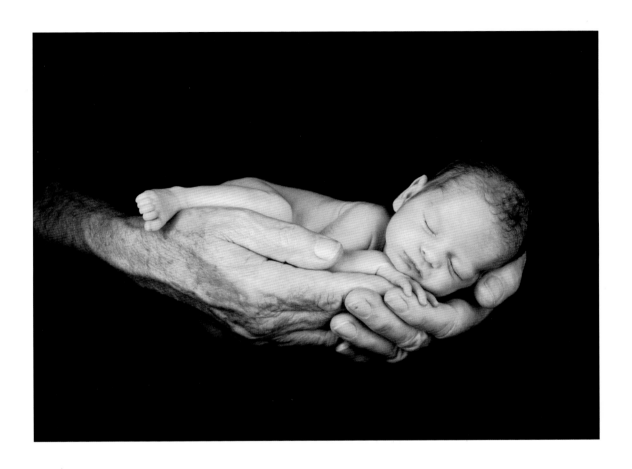

\mathcal{W}e can do no great things – only small things with great love.

Mother Teresa (1910–1997)

Name
...

Address
...

Fax/Email
...

Phone(s)
...

Name
...

Address
...

Fax/Email
...

Phone(s)
...

Name
...

Address
...

Fax/Email
...

Phone(s)
...

Name
...

Address
...

Fax/Email
...

Phone(s)
...

Name
..

Address
..

Fax/Email
..

Phone(s)
..

Name
..

Address
..

Fax/Email
..

Phone(s)
..

Name
..

Address
..

Fax/Email
..

Phone(s)
..

Name
..

Address
..

Fax/Email
..

Phone(s)
..

Name

...

Address

...

Fax/Email

...

Phone(s)

...

Name

...

Address

...

Fax/Email

...

Phone(s)

...

Name

...

Address

...

Fax/Email

...

Phone(s)

...

Name

...

Address

...

Fax/Email

...

Phone(s)

...

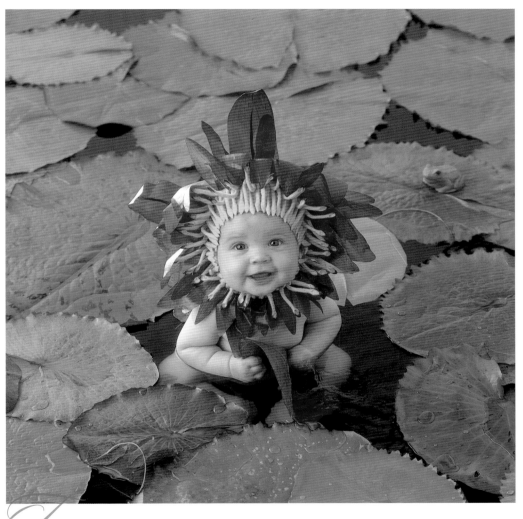

*T*he smiles of infants are said to be the first fruits of human reason.

Rev. Henry N. Hudson

Name

Address

Fax/Email

Phone(s)

Name

Address

Fax/Email

Phone(s)

Name

Address

Fax/Email

Phone(s)

Name

Address

Fax/Email

Phone(s)

Name

Address

Fax/Email

Phone(s)

Name

Address

Fax/Email

Phone(s)

Name

Address

Fax/Email

Phone(s)

Name

Address

Fax/Email

Phone(s)

Name

Address

Fax/Email

Phone(s)

Name

Address

Fax/Email

Phone(s)

Name

Address

Fax/Email

Phone(s)

Name

Address

Fax/Email

Phone(s)

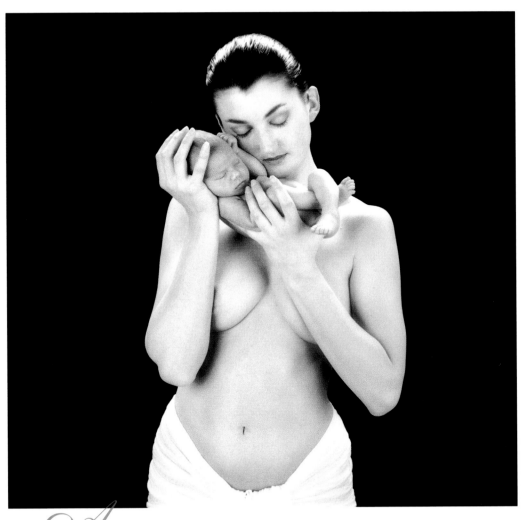

\mathcal{A} mother understands what a child does not say.

Proverb

Name

Address

Fax/Email

Phone(s)

Name

Address

Fax/Email

Phone(s)

Name

Address

Fax/Email

Phone(s)

Name

Address

Fax/Email

Phone(s)

Name
..

Address
..

Fax/Email
..

Phone(s)
..

Name
..

Address
..

Fax/Email
..

Phone(s)
..

Name
..

Address
..

Fax/Email
..

Phone(s)
..

Name
..

Address
..

Fax/Email
..

Phone(s)
..

Name

Address

Fax/Email

Phone(s)

Name

Address

Fax/Email

Phone(s)

Name

Address

Fax/Email

Phone(s)

Name

Address

Fax/Email

Phone(s)

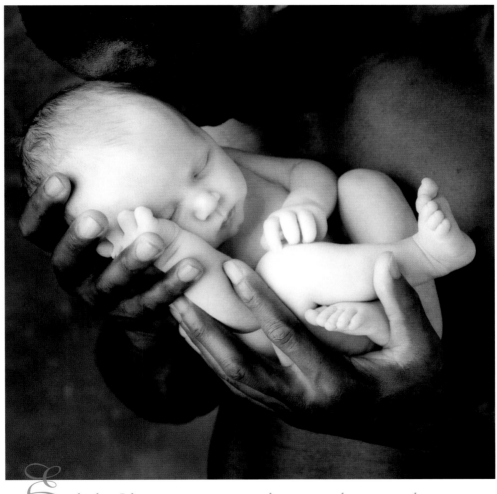

Each day I love you more ... today, more than yesterday ... and less than tomorrow.

Rosemonde Gérard

Name
...

Address
...

Fax/Email
...

Phone(s)
...

Name
...

Address
...

Fax/Email
...

Phone(s)
...

Name
...

Address
...

Fax/Email
...

Phone(s)
...

Name
...

Address
...

Fax/Email
...

Phone(s)
...

Name
..

Address
..

Fax/Email
..

Phone(s)
..

Name
..

Address
..

Fax/Email
..

Phone(s)
..

Name
..

Address
..

Fax/Email
..

Phone(s)
..

Name
..

Address
..

Fax/Email
..

Phone(s)
..

Name

Address

Fax/Email

Phone(s)

Name

Address

Fax/Email

Phone(s)

Name

Address

Fax/Email

Phone(s)

Name

Address

Fax/Email

Phone(s)

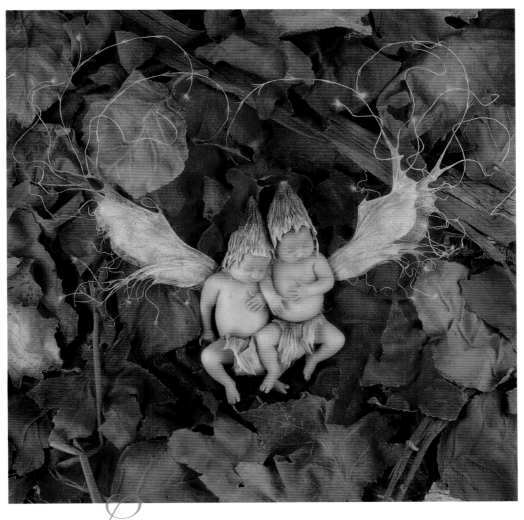

*L*ife itself is the most wonderful fairy tale.

Hans Christian Andersen (1805–1875)

Name

Address

Fax/Email

Phone(s)

Name

Address

Fax/Email

Phone(s)

Name

Address

Fax/Email

Phone(s)

Name

Address

Fax/Email

Phone(s)

Name

Address

Fax/Email

Phone(s)

Name

Address

Fax/Email

Phone(s)

Name

Address

Fax/Email

Phone(s)

Name

Address

Fax/Email

Phone(s)

Name

Address

Fax/Email

Phone(s)

Name

Address

Fax/Email

Phone(s)

Name

Address

Fax/Email

Phone(s)

Name

Address

Fax/Email

Phone(s)

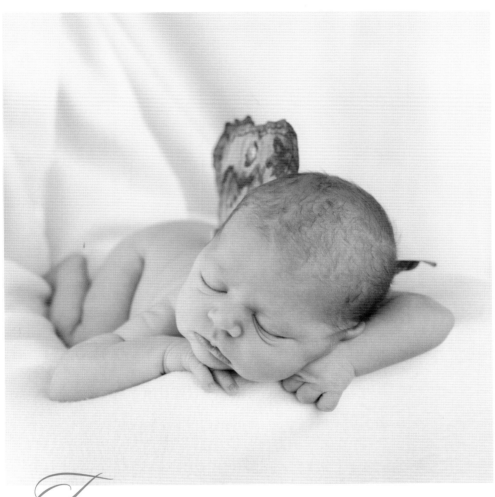

\mathcal{T}here are only two lasting bequests we can hope to give
our children. One of these is roots; the other, wings.

Cecilia Lasbury

Name

Address

Fax/Email

Phone(s)

Name

Address

Fax/Email

Phone(s)

Name

Address

Fax/Email

Phone(s)

Name

Address

Fax/Email

Phone(s)

Name
..

Address
..

Fax/Email
..

Phone(s)
..

Name
..

Address
..

Fax/Email
..

Phone(s)
..

Name
..

Address
..

Fax/Email
..

Phone(s)
..

Name
..

Address
..

Fax/Email
..

Phone(s)
..

Name

Address

Fax/Email

Phone(s)

Name

Address

Fax/Email

Phone(s)

Name

Address

Fax/Email

Phone(s)

Name

Address

Fax/Email

Phone(s)

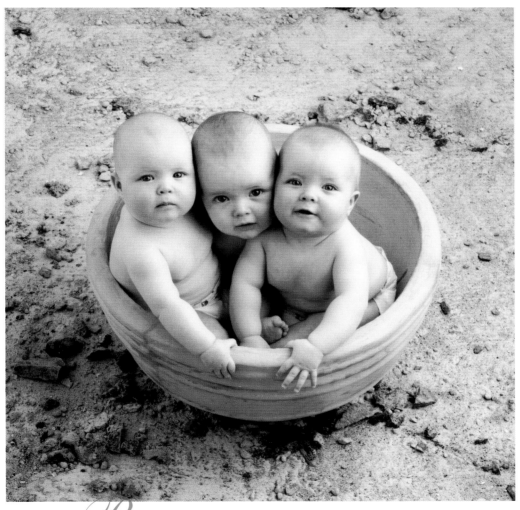

\mathcal{B}abies are such a nice way to start people.

Don Herold (1889–1966)

Name

Address

Fax/Email

Phone(s)

Name

Address

Fax/Email

Phone(s)

Name

Address

Fax/Email

Phone(s)

Name

Address

Fax/Email

Phone(s)

Name

Address

Fax/Email

Phone(s)

Name

Address

Fax/Email

Phone(s)

Name

Address

Fax/Email

Phone(s)

Name

Address

Fax/Email

Phone(s)

Name

Address

Fax/Email

Phone(s)

Name

Address

Fax/Email

Phone(s)

Name

Address

Fax/Email

Phone(s)

Name

Address

Fax/Email

Phone(s)

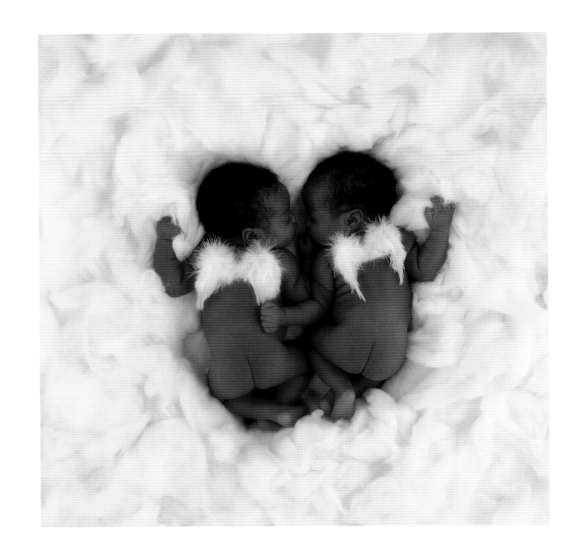

Name

Address

Fax/Email

Phone(s)

Name

Address

Fax/Email

Phone(s)

Name

Address

Fax/Email

Phone(s)

Name

Address

Fax/Email

Phone(s)

Name

Address

Fax/Email

Phone(s)

Name

Address

Fax/Email

Phone(s)

Name

Address

Fax/Email

Phone(s)

Name

Address

Fax/Email

Phone(s)

Name
...

Address
...

 Fax/Email
...

Phone(s)
...

Name
...

Address
...

 Fax/Email
...

Phone(s)
...

Name
...

Address
...

 Fax/Email
...

Phone(s)
...

How soft and fresh he breathes!
Look! He is dreaming! Visions sure of joy
Are gladdening his rest; and, ah! who knows
But waiting angels do converse in sleep
With babes like this!

Bishop Coxe (1818–1896)

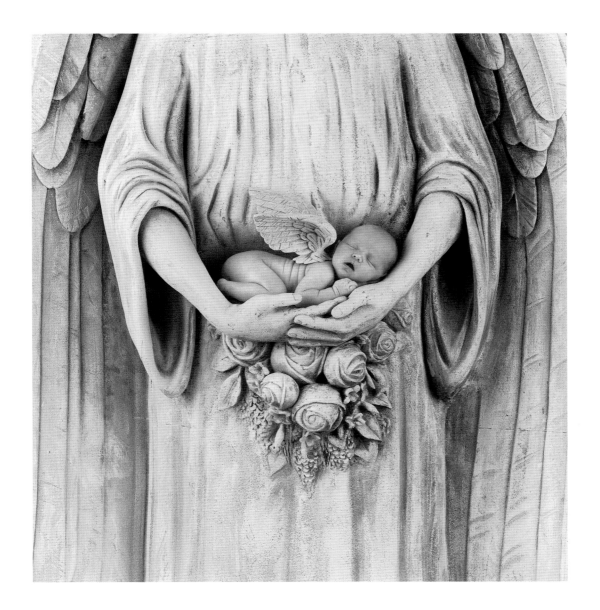

Name
..

Address
..

Fax/Email
..

Phone(s)
..

Name
..

Address
..

Fax/Email
..

Phone(s)
..

Name
..

Address
..

Fax/Email
..

Phone(s)
..

Name
..

Address
..

Fax/Email
..

Phone(s)
..

Name

Address

Fax/Email

Phone(s)

Name

Address

Fax/Email

Phone(s)

Name

Address

Fax/Email

Phone(s)

Name

Address

Fax/Email

Phone(s)

Name

Address

Fax/Email

Phone(s)

Name

Address

Fax/Email

Phone(s)

Name

Address

Fax/Email

Phone(s)

Name

Address

Fax/Email

Phone(s)

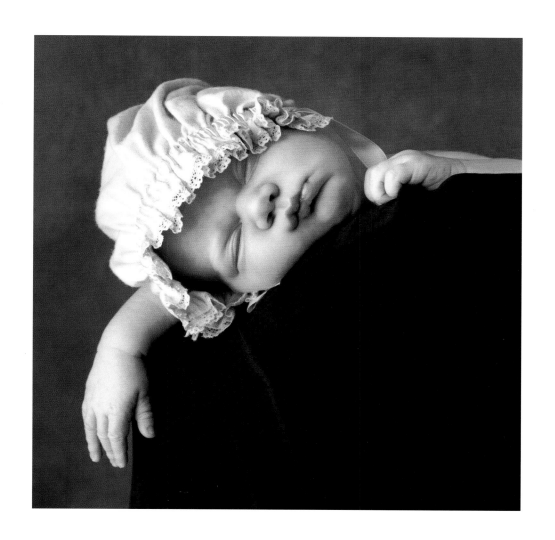

Name

Address

Fax/Email

Phone(s)

Name

Address

Fax/Email

Phone(s)

Name

Address

Fax/Email

Phone(s)

Name

Address

Fax/Email

Phone(s)

Name
..

Address
..

Fax/Email
..

Phone(s)
..

Name
..

Address
..

Fax/Email
..

Phone(s)
..

Name
..

Address
..

Fax/Email
..

Phone(s)
..

Name
..

Address
..

Fax/Email
..

Phone(s)
..

Name

Address

Fax/Email

Phone(s)

Name

Address

Fax/Email

Phone(s)

Name

Address

Fax/Email

Phone(s)

Name

Address

Fax/Email

Phone(s)

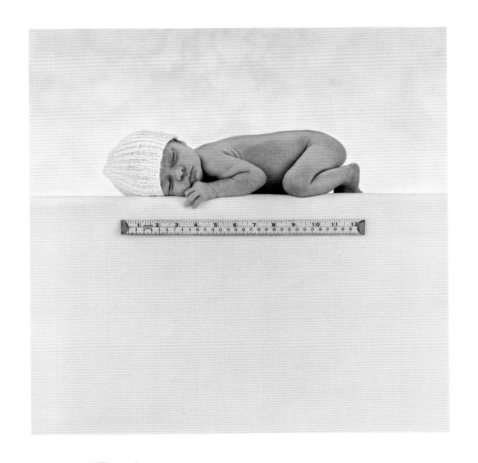

From small beginnings come great things.

Proverb

Name
..

Address
..

Fax/Email
..

Phone(s)
..

Name
..

Address
..

Fax/Email
..

Phone(s)
..

Name
..

Address
..

Fax/Email
..

Phone(s)
..

Name
..

Address
..

Fax/Email
..

Phone(s)
..

Name

Address

Fax/Email

Phone(s)

Name

Address

Fax/Email

Phone(s)

Name

Address

Fax/Email

Phone(s)

Name

Address

Fax/Email

Phone(s)

Name
..

Address
..

Fax/Email
..

Phone(s)
..

Name
..

Address
..

Fax/Email
..

Phone(s)
..

Name
..

Address
..

Fax/Email
..

Phone(s)
..

*O wonderful, wonderful,
and most wonderful wonderful!
and yet again wonderful.*

William Shakespeare (1564–1616)

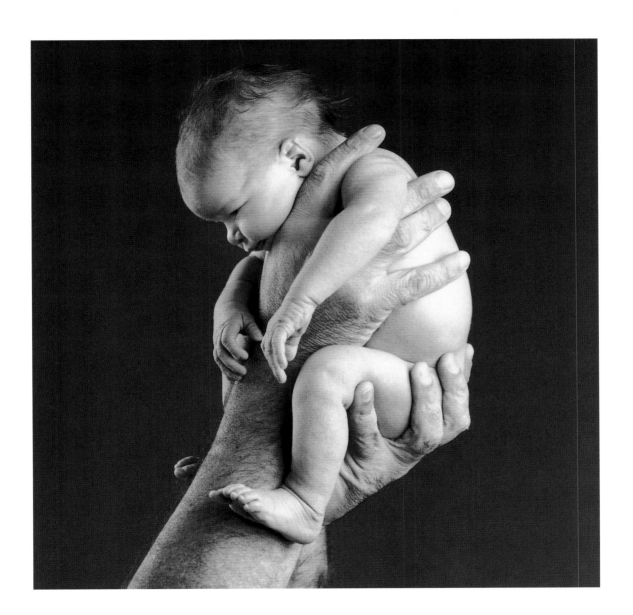

Name

Address

Fax/Email

Phone(s)

Name

Address

Fax/Email

Phone(s)

Name

Address

Fax/Email

Phone(s)

Name

Address

Fax/Email

Phone(s)

Name
...

Address
...

Fax/Email
...

Phone(s)
...

Name
...

Address
...

Fax/Email
...

Phone(s)
...

Name
...

Address
...

Fax/Email
...

Phone(s)
...

Name
...

Address
...

Fax/Email
...

Phone(s)
...

Name

Address

Fax/Email

Phone(s)

Name

Address

Fax/Email

Phone(s)

Name

Address

Fax/Email

Phone(s)

Name

Address

Fax/Email

Phone(s)

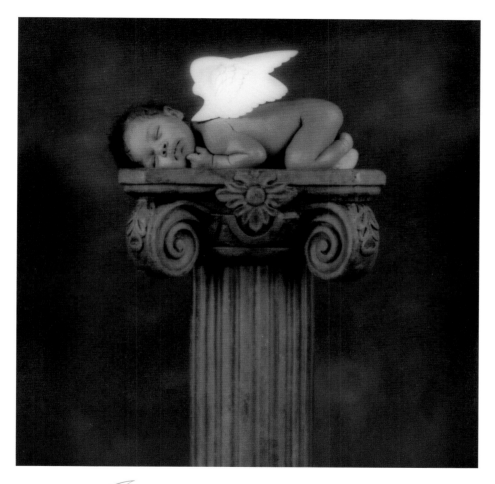

I have spread my dreams under your feet;
Tread softly because you tread on my dreams.

W. B. Yeats (1865–1939)

Name

Address

Fax/Email

Phone(s)

Name

Address

Fax/Email

Phone(s)

Name

Address

Fax/Email

Phone(s)

Name

Address

Fax/Email

Phone(s)

Name

Address

Fax/Email

Phone(s)

Name

Address

Fax/Email

Phone(s)

Name

Address

Fax/Email

Phone(s)

Name

Address

Fax/Email

Phone(s)

Name

Address

Fax/Email

Phone(s)

Name

Address

Fax/Email

Phone(s)

Name

Address

Fax/Email

Phone(s)

Name

Address

Fax/Email

Phone(s)

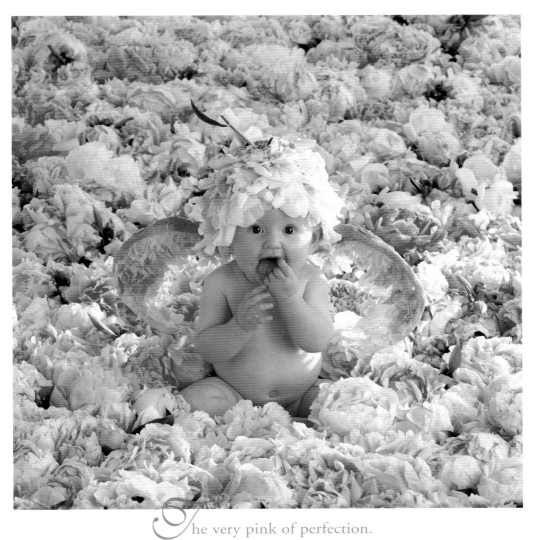

The very pink of perfection.

Oliver Goldsmith (1728–1774)

Name

Address

Fax/Email

Phone(s)

Name

Address

Fax/Email

Phone(s)

Name

Address

Fax/Email

Phone(s)

Name

Address

Fax/Email

Phone(s)

Name

Address

Fax/Email

Phone(s)

Name

Address

Fax/Email

Phone(s)

Name

Address

Fax/Email

Phone(s)

Name

Address

Fax/Email

Phone(s)

Name

Address

Fax/Email

Phone(s)

Name

Address

Fax/Email

Phone(s)

Name

Address

Fax/Email

Phone(s)

Name

Address

Fax/Email

Phone(s)

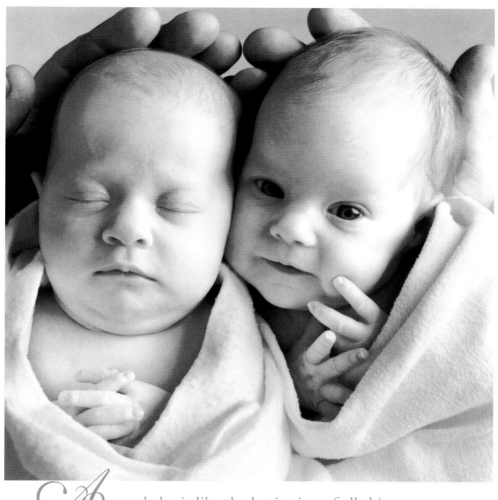

\mathscr{A} new baby is like the beginning of all things –
wonder, hope, a dream of possibilities.

Eda J. Leshan (1922–)

Name

Address

Fax/Email

Phone(s)

Name

Address

Fax/Email

Phone(s)

Name

Address

Fax/Email

Phone(s)

Name

Address

Fax/Email

Phone(s)

Name

Address

Fax/Email

Phone(s)

Name

Address

Fax/Email

Phone(s)

Name

Address

Fax/Email

Phone(s)

Name

Address

Fax/Email

Phone(s)

Name
...

Address
...

Fax/Email
...

Phone(s)
...

Name
...

Address
...

Fax/Email
...

Phone(s)
...

Name
...

Address
...

Fax/Email
...

Phone(s)
...

Name
...

Address
...

Fax/Email
...

Phone(s)
...

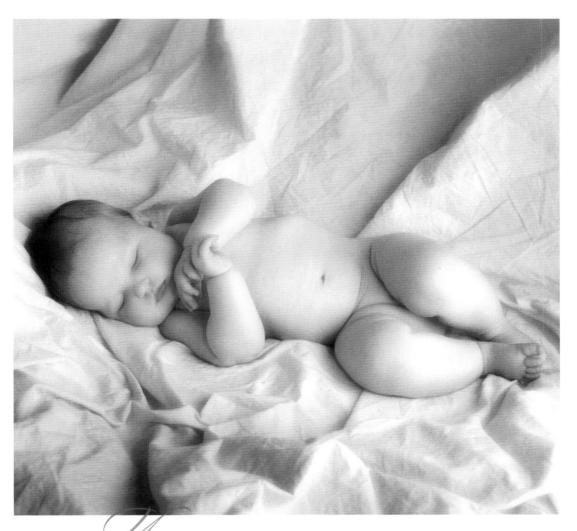

You should have a softer pillow than my heart.

Lord Byron (1788–1824)

Name

Address

Fax/Email

Phone(s)

Name

Address

Fax/Email

Phone(s)

Name

Address

Fax/Email

Phone(s)

Name

Address

Fax/Email

Phone(s)

Name

Address

Fax/Email

Phone(s)

Name

Address

Fax/Email

Phone(s)

Name

Address

Fax/Email

Phone(s)

Name

Address

Fax/Email

Phone(s)

Name

Address

Fax/Email

Phone(s)

Name

Address

Fax/Email

Phone(s)

Name

Address

Fax/Email

Phone(s)

It was the Rainbow gave thee birth,

And left thee all her lovely hues.

William Henry Davies (1871–1940)

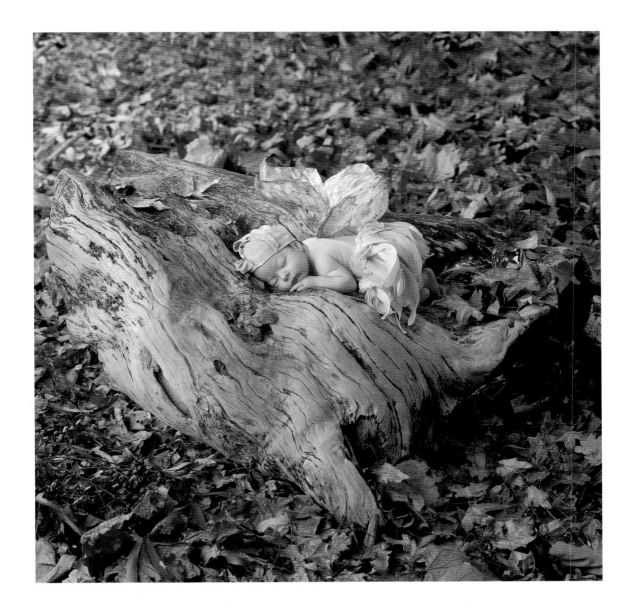

Name
...

Address
...

 Fax/Email
...

Phone(s)
...

Name
...

Address
...

 Fax/Email
...

Phone(s)
...

Name
...

Address
...

 Fax/Email
...

Phone(s)
...

Name
...

Address
...

 Fax/Email
...

Phone(s)
...

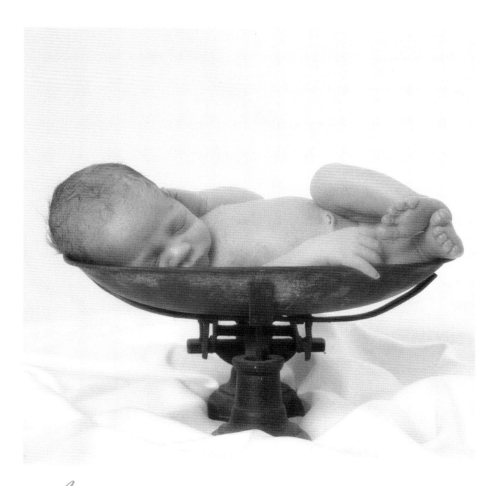

\mathcal{A} perfect example of minority rule is a baby in the house.

Anonymous

Name

Address

Fax/Email

Phone(s)

Name

Address

Fax/Email

Phone(s)

Name

Address

Fax/Email

Phone(s)

Name

Address

Fax/Email

Phone(s)

Name
..

Address
..

Fax/Email
..

Phone(s)
..

Name
..

Address
..

Fax/Email
..

Phone(s)
..

Name
..

Address
..

Fax/Email
..

Phone(s)
..

Name
..

Address
..

Fax/Email
..

Phone(s)
..

Name
..

Address
..

 Fax/Email
..

Phone(s)
..

Name
..

Address
..

 Fax/Email
..

Phone(s)
..

Name
..

Address
..

 Fax/Email
..

Phone(s)
..

Name
..

Address
..

 Fax/Email
..

Phone(s)
..

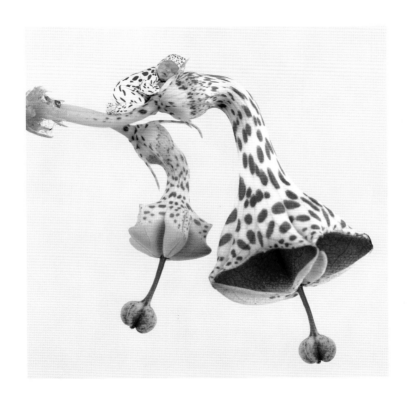

𝒮mall is beautiful.

Proverb

Name

Address

Fax/Email

Phone(s)

Name

Address

Fax/Email

Phone(s)

Name

Address

Fax/Email

Phone(s)

Name

Address

Fax/Email

Phone(s)

Name
..

Address
..

Fax/Email
..

Phone(s)
..

Name
..

Address
..

Fax/Email
..

Phone(s)
..

Name
..

Address
..

Fax/Email
..

Phone(s)
..

Name
..

Address
..

Fax/Email
..

Phone(s)
..

Name

Address

Fax/Email

Phone(s)

Name

Address

Fax/Email

Phone(s)

Name

Address

Fax/Email

Phone(s)

Name

Address

Fax/Email

Phone(s)

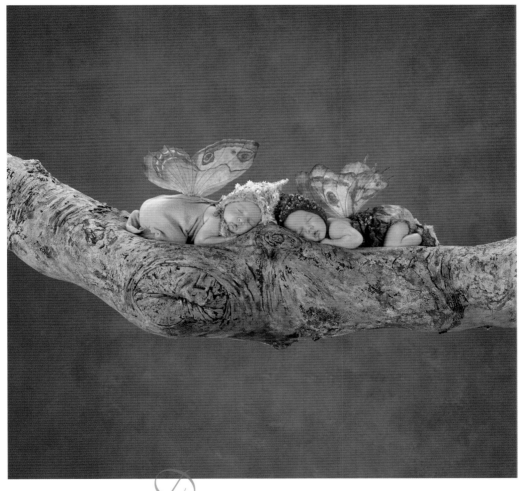

Do you believe in fairies?

... If you believe, clap your hands!

J. M. Barrie (1860–1937)

Name

Address

Fax/Email

Phone(s)

Name

Address

Fax/Email

Phone(s)

Name

Address

Fax/Email

Phone(s)

Name

Address

Fax/Email

Phone(s)

Name

Address

Fax/Email

Phone(s)

Name

Address

Fax/Email

Phone(s)

Name

Address

Fax/Email

Phone(s)

Name

Address

Fax/Email

Phone(s)

Name

Address

Fax/Email

Phone(s)

Name

Address

Fax/Email

Phone(s)

Name

Address

Fax/Email

Phone(s)

Name

Address

Fax/Email

Phone(s)

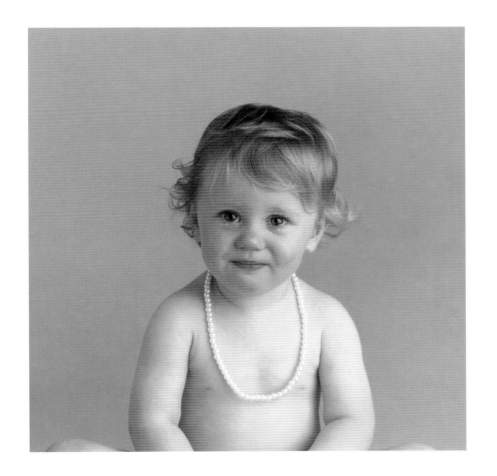

*T*ears ... the diamonds of the eye.

Rev. Dr. Davies

Name
..

Address
..

Fax/Email
..

Phone(s)
..

Name
..

Address
..

Fax/Email
..

Phone(s)
..

Name
..

Address
..

Fax/Email
..

Phone(s)
..

Name
..

Address
..

Fax/Email
..

Phone(s)
..

Name
..

Address
..

Fax/Email
..

Phone(s)
..

Name
..

Address
..

Fax/Email
..

Phone(s)
..

Name
..

Address
..

Fax/Email
..

Phone(s)
..

Name
..

Address
..

Fax/Email
..

Phone(s)
..

Name

Address

Fax/Email

Phone(s)

Name

Address

Fax/Email

Phone(s)

Name

Address

Fax/Email

Phone(s)

Name

Address

Fax/Email

Phone(s)

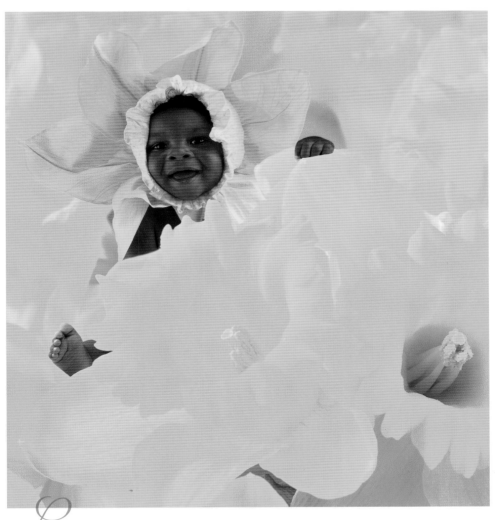

*L*ittle children are the most lovely flowers this side of Eden.

Rev. Dr. Davies

Name

Address

Fax/Email

Phone(s)

Name

Address

Fax/Email

Phone(s)

Name

Address

Fax/Email

Phone(s)

Name

Address

Fax/Email

Phone(s)

Name

Address

Fax/Email

Phone(s)

Name

Address

Fax/Email

Phone(s)

Name

Address

Fax/Email

Phone(s)

Name

Address

Fax/Email

Phone(s)

Name
...

Address
...

Fax/Email
...

Phone(s)
...

Name
...

Address
...

Fax/Email
...

Phone(s)
...

Name
...

Address
...

Fax/Email
...

Phone(s)
...

*Happiness is the intoxication produced by the moment
of poise between a satisfactory past,
and an immediate future, rich with promise.*

Ella Maillart (1903–)

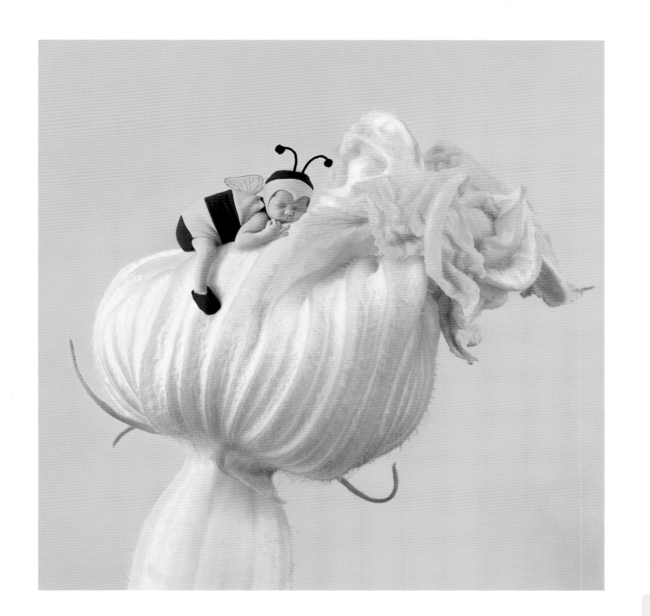

W

Name

Address

Fax/Email

Phone(s)

Name

Address

Fax/Email

Phone(s)

Name

Address

Fax/Email

Phone(s)

Name

Address

Fax/Email

Phone(s)

Name

Address

Fax/Email

Phone(s)

Name

Address

Fax/Email

Phone(s)

Name

Address

Fax/Email

Phone(s)

Name

Address

Fax/Email

Phone(s)

Name
...

Address
...

Fax/Email
...

Phone(s)
...

Name
...

Address
...

Fax/Email
...

Phone(s)
...

Name
...

Address
...

Fax/Email
...

Phone(s)
...

The decision to have a child is to accept that your heart will forever walk about outside of your body.

Katharine Hadley

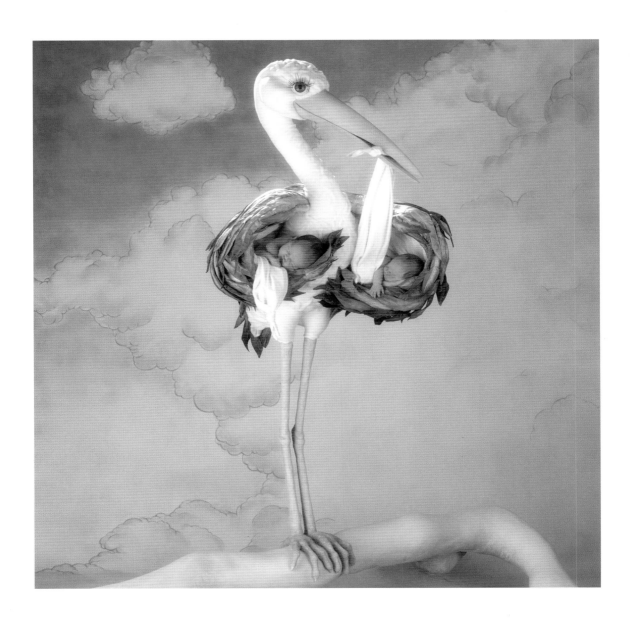

Name

Address

Fax/Email

Phone(s)

Name

Address

Fax/Email

Phone(s)

Name

Address

Fax/Email

Phone(s)

Name

Address

Fax/Email

Phone(s)

Name

Address

Fax/Email

Phone(s)

Name

Address

Fax/Email

Phone(s)

Name

Address

Fax/Email

Phone(s)

Name

Address

Fax/Email

Phone(s)

ANNE GEDDES ™

ISBN 0-8362-1925-2

© Anne Geddes 1999

Published in 1999 by Photogenique Publishers
(a division of Hodder Moa Beckett)
Studio 3.16, Axis Building, 1 Cleveland Road, Parnell
Auckland, New Zealand

First Canadian edition published in 1999 by Andrews McMeel Publishing,
4520 Main Street, Kansas City, MO 64111-7701

Designed by Lucy Richardson
Produced by Kel Geddes
Color separations by MH Group

Printed by Midas Printing Limited, Hong Kong